GEORGIA
O'KEEFFE
in
NEW MEXICO

A Guide

By Marsha Bellavance-Johnson
Illustrated by Allison Gosney

Published by
THE COMPUTER LAB
Ketchum, Idaho

FAMOUS FOOTSTEPS™

guide booklets
about famous people
in their favorite places

Front cover photo:
Georgia O'Keeffe, Laura Gilpin, 5x4 safety negative,
1953, © 1979, Amon Carter Museum, Fort Worth,
Texas, Laura Gilpin collection # P1979.230.4284.

Page nine photo:
Georgia O'Keeffe in Taos, 1929, courtesy Museum of
New Mexico.

Back cover photo:
Georgia O'Keeffe, Abiquiu, New Mexico, Laura
Gilpin, 5x4 safety negative, 1953, © 1979, Amon
Carter Museum, Fort Worth, Texas, Laura Gilpin
collection #4036.2.

Library of Congress Catalog Card Number: 98-93007

ISBN 0-929-70914-4

FAMOUS FOOTSTEPS™

guide booklets
about famous people
in their favorite places

Titles available:

Kit Carson in the West - $4.95
Emily Dickinson in Amherst - $4.95
Ernest Hemingway in Idaho - $7.95
Ernest Hemingway in Key West - $7.95
John Fitzgerald Kennedy in Massachusetts - $4.95
Jack London in California - $4.95
Marilyn Monroe in Hollywood - $4.95
Georgia O'Keeffe in New Mexico - $7.95
Mark Twain in the U.S.A. - $4.95
Tennessee Williams in Key West and Miami - $4.95

For retail orders contact your:
Local Bookstore
Amazon.Com
Baker&Taylor
Barnes & Noble

For comments, suggestions and wholesale
orders contact:
THE COMPUTER LAB
P.O. Box 4300, Ketchum, Idaho USA 83340
phone (208) 726-4717 or fax (208) 726-8413

Table of Contents

Table of Contents..7
Note to Readers...8
Photo..9
Chronology..11
Map of New Mexico...12
Brief Biography ...13
Map of Taos...25
Mable Dodge Luhan House...27
Church of San Francisco de Asis...29
Lawrence Ranch and Shrine...31
Map of Abiquiu Area..32-33
Ghost Ranch Conference Center..35
Rancho de los Burros..37
Museums of Ghost Ranch...39
Ghost Ranch Living Museum...41
Pedernal..43
Bode's General Store...45
Abiquiu House..47
Map of Santa Fe...49
Santa Fe Museum...51
Music ...53
The Georgia O'Keeffe Museum..55
Albuquerque Museums...57
Bibliography ...59

Note to Readers

I hope that readers will find this guide to Georgia O'Keeffe in New Mexico helpful. The O'Keeffe museum which opened in Santa Fe in 1997 has stimulated renewed interest in the art and life of Georgia O'Keeffe.

One explanation for her popularity might be the accessibility of her subject matter. Trees, bones, shells, fossils, rivers, hills and flowers are easily recognizable by the general public. For nearly fifty years O'Keeffe painted the landscape, fauna and fossils of New Mexico in a way that almost anyone can relate to. At other times she could turn the representation of a bone and sky into a sophisticated abstraction.

Today the visitor to New Mexico can still experience many of the things which attracted O'Keeffe: landscape, solitude, hiking, camping, adobe, the ceremonial dances, music and above all the vast sky. Pedernal, the Chama River and the famous red and yellow cliffs can even be viewed from the comfort of a vehicle on highway 84 near Abiquiu.

Miss O'Keeffe, as she was generally called, continues to be honored in various ways: in addition to the Georgia O'Keeffe Museum in Santa Fe, there is now a school named after her in Albuquerque and a commemorative stamp featuring her red poppy painting was issued by the U.S. Postal Service in 1997.

I would like to thank all of the people who were helpful with this project. Those deserving special attention include: the late Professor Douglas George, Benjamin Romero, Jim Kempes, Cynthia Lukens, Art Bachrach, Sophie Martin, Nola Scott, Judy Lopez, Constance Arachy, Lee Bellavance and Susan Bailey. And thanks especially to my husband, Harold Johnson.

I want to remind readers to please respect private property when exploring the places described here. Admirers of O'Keeffe should know that she was a very private person and respected the privacy of others.

Sincerely,
Marsha Bellavance

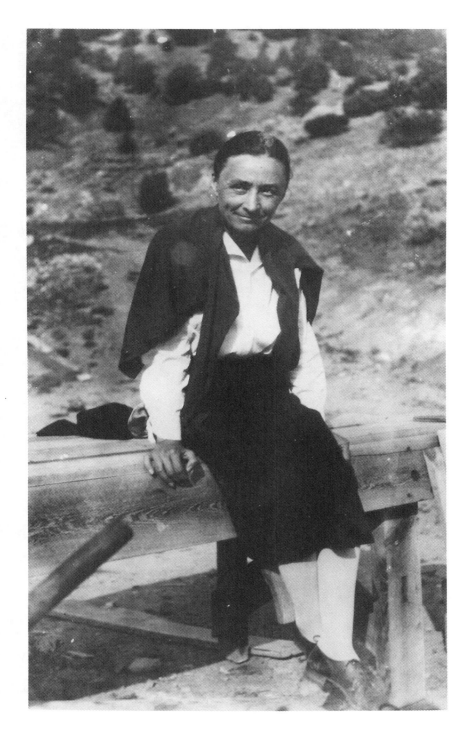

Chronology

1887 - Born in Sun Prairie, Wisconsin on November 15.

1903 - Moves with family to Williamsburg, Virginia.

1905 - Graduates from Chatham Episcopal Institute

1905 - Attends Art Institute of Chicago.

1907 - Resumes studies at Art Students League in New York.

1908-1911 - Supports herself working as an illustrator.

1911 - Back in Virginia she substitute teaches art at Chatham.

1912 - Takes Alon Bement's art class, University of Virginia.

1912 - Teaches art in Amarillo, Texas.

1913 - Teaching assistant for Bement's art class in Virginia.

1914 - Studies with Arthur Dow at Columbia in New York.

1915 - Teaches college art in Columbia, South Carolina.

1916 - O'Keeffe's drawings shown to Stieglitz by A. Pollitzer.

1916 - First exhibit at Stieglitz's 291 Gallery in New York.

1916 - Teaches at West Texas State in Canyon, Texas.

1917 - First visit to New Mexico.

1918 - Moves to New York City to share life with Stieglitz. Spends summers with his family at Lake George.

1927 - O'Keeffe Exhibition at the Brooklyn Museum.

1929 - Visits New Mexico as guest of Mabel Dodge Luhan.

1933 - Has breakdown and is hospitalized.

1934 - Metropolitan Museum of Art buys its first O'Keeffe. She spends the summers at Ghost Ranch.

1945 - O'Keeffe buys house in Abiquiu.

1946 - Stieglitz dies.

1950 - Last show at An American Place, Stiegliz's gallery.

1953 - First trip to Europe, travels a lot in the next 30 years.

1964 - Honorary Doctor of Fine Arts, Univ. of New Mexico.

1971 - Loses central vision.

1973 - Meets Juan Hamilton.

1977 - Receives the Presidential Medal of Freedom.

1986 - Dies on March 6 in Santa Fe.

New Mexico

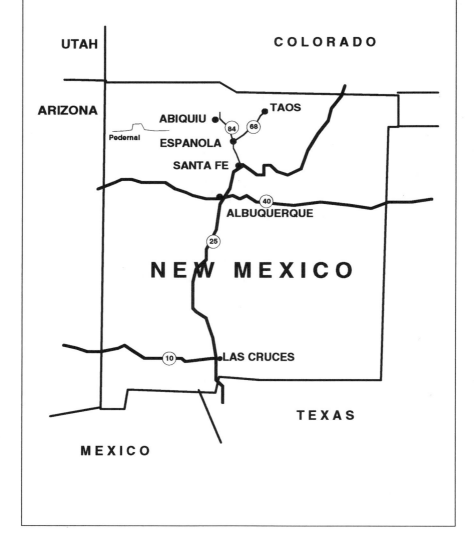

UTAH

COLORADO

ARIZONA

TAOS

ABIQUIU

84 68

Pedernal

ESPANOLA

SANTA FE

40

ALBUQUERQUE

25

NEW MEXICO

LAS CRUCES

10

TEXAS

MEXICO

Brief Biography

Georgia O'Keeffe, a pioneer of modern American painting, is strongly and justifiably identified with New Mexico in art, life, and legend. She first traveled to New Mexico in 1917, in her thirtieth year. In 1929, O'Keeffe started to visit regularly and was a permanent resident of the state from 1949 until her death in 1986. Her paintings show that she was continually inspired by the unique feeling and space of the New Mexican light and landscape. The strange distortions of space, distance and perspective which occur in the immense areas of the New Mexican sky and desert she called "from the faraway nearby".

Georgia Totto O'Keeffe was born on November 15, 1887, in Sun Prairie, Wisconsin. The landscapes of her childhood were the vast spaces and empty places of the plains. During her long life, too many trees and buildings tended to make her feel oppressed and claustrophobic. Her family of two brothers and four sisters lived on a large farm where the material and emotional atmosphere was frugal and austere but the intellectual environment was rich and varied. The children were encouraged by their mother who often read aloud to them. Georgia was especially fascinated with wild west stories and tales of James Fenimore Cooper, Kit Carson, and Buffalo Bill Cody.

As a child of eleven, Georgia took drawing and painting lessons at home with her two sisters, then once a month with a local watercolorist. By the time she was in the eighth grade Georgia told a young friend that she wanted to be an artist. Music was also important to her during her entire life and she played both the piano and violin.

Georgia was educated at several schools and each seems to have left an impression. At Sacred Heart Academy in Madison, Wisconsin her parents paid extra for art lessons from Sister Angelique. She got good grades and received a prize in history as well as a gold pin for drawing. The next year she stayed with her Aunt Ida in Milwaukee. There, the school art teacher brought flowers for the class to examine. This aroused

Georgia's interest in details and in using growing things and natural specimens as objects to paint.

In 1903, when tuberculosis threatened the family, they moved to Williamsburg, Virginia. They had expected a healthier climate but found just the opposite. Her father was unfortunately involved in one failing business venture after another. But Georgia was an independent northern girl and adjusted easily to yet another school. Although she wore simple dark dresses and was "different" from the southern belles, she was still popular. Pursuing her music, she continued playing the piano, was art editor of the school year book, and learned under the positive influence of her art teacher, Elizabeth May Willis. Academically she was average but was always bothered by poor spelling, although her superiority at art was generally recognized. In 1905 she graduated from the Chatham Episcopal Institute in Virginia and planned to "give up everything for her art." Because she was their best art student, the school kept one of her paintings, which was later destroyed in a fire. In her 1977 book, *Georgia O'Keeffe,* she recalled disliking the "pretentious" frames her mother used to display these early efforts. For the rest of her life, O'Keeffe liked only the simplest frames for her paintings.

In the fall of 1905 O'Keeffe studied at the prestigious Art Institute of Chicago. She lived near the Institute at the home of her maternal uncle, Charles Totto, and his wife. Only seventeen when she enrolled, it was the first time she was surrounded by other students with superior skills. Intimidated at first, she found the anatomy class shocking and had no interest in the subject. This disinterest was so deep it endured for decades and she did only a few human studies in her lifetime. Her Chicago professors emphasized a classical academic tradition with much copying of masterpieces. Georgia did well but became ill with typhoid fever while at home for the summer and was unable to return to school in Chicago. She had a lifetime pattern of intense creativity interspersed with periods of enervation and debilitating illness.

When she resumed her studies in 1907, it was at the Art Students League in New York City which was the *alma mater*

of her former headmistress at Chatham. Arriving in New York on her own and seeking a career in art made her atypical for a female of the times. Her independence and determination set her apart, as always, from her classmates. In New York her favorite course was a still life class taught by William Merritt Chase, which required a daily painting. Unlike the Art Institute in Chicago, individuality, speed, vitality, and color were encouraged. Even in that company of elite art students, O'Keeffe's talents were recognized. In Chase's class she won a prestigious first prize for her still life, *Rabbit and Copper Pot.*

While in New York she also visited photographer Alfred Stieglitz's "291" Gallery. It was one of the few art galleries in the United States that exhibited works by modern European artists such as Rodin, Cezanne, Picasso and Matisse. O'Keeffe had had only a few opportunities to see Modern European art and was much less influenced by Cubism and other European movements than were many of her contemporaries. Although she did well in New York, she soon had to leave because of a family emergency.

By 1908 her family's financial situation had deteriorated. O'Keeffe needed to be self-sufficient. She gave up school, moved to Chicago with her relatives and found a job to support herself. She worked as an illustrator for two years, but eventually measles and the resulting eyestrain left her unable to continue that work. Sick and discouraged, O'Keeffe had even decided to give up art.

Meanwhile Georgia's mother Ida began showing symptoms of tuberculosis and the family moved again to the healthier climate of Charlottesville. By 1911, O'Keeffe was back in Virginia and was hired as a substitute teacher at her old school, Chatham. That stimulated her interest in art again. She and her sisters, Anita and Ida were able to attend the 1912 summer session at the University of Virginia. (It was the only time of the year women were allowed to study!) She enrolled in a class taught by Alon Bement, who immediately recognized O'Keeffe's talent. Bement taught the Arthur Wesley Dow method which used experimentation with abstract shapes in

order to learn about proportion, shape and balance. Thus inspired, O'Keeffe returned to art.

A few months later she was off to Amarillo, Texas, where she had a job as school drawing supervisor. It was her first introduction to the West and O'Keeffe loved the wind and space of the plains surrounding Amarillo. In those days it was still a frontier town and shipping center for many large cattle drives. She was considered eccentric and unusual: a career woman living on her own at the Magnolia Hotel rather than in a boardinghouse with the other teachers.

In the summer of 1913 she was back at the University of Virginia where she now had a position as Bement's teaching assistant. She was further influenced by his teaching of Dow's concepts: that every act and space should reflect beauty. Bement acted as a mentor and recommended readings to O'Keeffe; especially significant was Wassily Kandinsky's *Concerning the Spiritual in Art*. His theories about emotion, color and music always interested her. Years later in Abiquiu, when she could hardly see any longer, she had an assistant read to her from the Kandinsky book. It was under this influence that she painted *Tent Door at Night*, a watercolor now owned by the University of New Mexico.

Bement encouraged O'Keeffe to go to New York City where she would be able to study with Dow himself. When the school board in Texas insisted she use only one text she quit and left. She arrived at Columbia Teachers College in New York City in 1914. Again she was outstanding in her art classes. She was interested in the relationship between music and art and the use of color and form to represent emotions the way music evokes feelings with sound. She later did a series of paintings titled, *Music - Pink and Blue*.

Now nearly 27 years old and nicknamed "Pat", she had only enough money to study for a year. She was considered attractive and popular and became friends with fellow student Anita Pollitzer. Together they often visited Alfred Stieglitz's Gallery. Modernism was changing the art world and Stieglitz promoted innovative works at his gallery "291" where Georgia saw works by Braque, Picasso and Marin.

Needing to support herself, by the fall of 1915 O'Keeffe had reluctantly left school and was teaching college-level art in Columbia, South Carolina. This was a critical period in her artistic development. She decided that all her paintings had been done to please different instructors. Now she decided to start anew, working only in charcoal. Her desire was to express emotions on paper. She sent a roll of these drawings to Anita Pollitzer, with instructions to show them to no one. The non-representational charcoals so excited Anita that she showed them to Alfred Stieglitz. He was immediately moved and reportedly exclaimed, "Finally, a woman on paper!" Shortly afterwards O'Keeffe and Stieglitz began their correspondence.

O'Keeffe, however, was unhappy in South Carolina and may have had problems with the school administration. She accepted a teaching job in Canyon, Texas. But before going she had to complete a required course so she spent the spring of 1916 studying in New York again. Unknown to her, the first show of her works had opened that May in New York at Stieglitz's "291" gallery. Stieglitz, was unable to contact her but had presented her first exhibit anyway. When she learned that he was exhibiting her pictures, she asked him to take them down! Finally, he prevailed and the show stayed up.

Sadly, it was also in May of 1916 that O'Keeffe's mother, Ida died from the tuberculosis which had plagued her for years. The family separated, although O'Keeffe remained close to her sisters Claudia, Ida and Anita. That fall O'Keeffe was in Canyon, Texas, teaching at West Texas State Normal College. Considered an eccentric, she frequently dressed in black and loved walking on the seemingly endless prairie straight into the morning or nighttime sky. She produced many works in Texas, such as *Evening Star* and *Light Coming on the Plains*, which capture this sense of space and light. (Several paintings from that period called *The Canyon Suite* were recently rediscovered.) While on a vacation from teaching in Texas, she impulsively went to New York for ten days. She saw Stieglitz, who had just had a second exhibit of her work. Their relationship intensified and he photographed her, posing her with her paintings.

Back in Texas, her sister Claudia was living with her and attending the college. While on a vacation trip to Colorado their train was detoured through New Mexico by floods. So, it was by pure chance that she visited Santa Fe, New Mexico in the summer of 1917. Although she didn't return until 1929, she later wrote that she "loved the sky out there" and was "always on her way back."

O'Keeffe was in Texas until June, 1918. After her sister left she felt isolated and depressed and was debilitated by an attack of deadly influenza. Stieglitz sent their mutual friend, photographer Paul Strand to save her and bring her back. She resisted but by June Stieglitz finally convinced her to join him in New York. (He was still married, but later divorced.) His family accepted her, and she stayed at the studio of Stieglitz's niece on 59th Street. Although much older and without much money, he made it possible for her to devote herself to painting and arranged for her to have annual shows. These were happy years for O'Keeffe who painted brightly colored abstract works.

In 1919 O'Keeffe began painting flowers as well as her abstractions of light and space. As a result of her move, she also started to paint the city. New York City inspired her many cityscape and skyscraper paintings such as *Shelton with Sunspots*, *New York with Moon*, *City Night*, *East River, New York,* and *Radiator Building.*

O'Keeffe began to share Stieglitz's busy life. She posed for hundreds of photographs for him and he arranged her shows. In 1921, an exhibit of nude photographs he had taken of her were shocking to many and thrust her into a slightly notorious limelight. Despite the sexual connotations of hundreds of nude studies of O'Keeffe, theirs was really a great intellectual partnership. On December 11, 1924, thirty-seven year old Georgia O'Keeffe and sixty-one year old Alfred Stieglitz were married. The marriage had been forced by a child: Stieglitz's estranged adult daughter, Kitty. Stieglitz was convinced a reconciliation would occur once he was properly married. He was wrong. For the next four years, the couple lived in New York City and spent every summer at the Stieglitz family

cottage (with his family) on Lake George as Stieglitz had been accustomed to doing for many years.

O'Keeffe, who kept her own name, became preoccupied with household responsibilities. At Lake George especially, there was obligatory entertaining of family and friends. In true Victorian style the place was crammed with both objects and family. The profusion of responsibilities, people, objects and trees all contributed to making O'Keeffe feel depressed and oppressed. She needed light, space and emptiness.

With all the commotion it was difficult for O'Keeffe to find time and space to paint. Finally, after much debate, she decided to spend a summer in the West. Stieglitz, who was twenty-three years older and had a bad heart, never traveled West with his wife. In the spring of 1929, at the age of 42, O'Keeffe went to New Mexico for four months with Rebecca Strand, the wife of Paul Strand. She stayed in Taos with the famous heiress, Mabel Dodge Luhan (see page 27). D.H. Lawrence, Willa Cather, Ansel Adams and other celebrities had also stayed at Mabel's. Out West, O'Keeffe bought a Ford and learned to drive which were symbolic of her new found independence and freedom. She also went camping and horseback riding. She was truly inspired by the uniqueness of the area and she painted such local scenes as the Ranchos Church (see page 29), the Taos Pueblo, kachina dolls, landscapes, Penitente crosses, and flowers. She also spent several weeks visiting her friend, painter Dorothy Brett at the Kiowa (Lawrence) Ranch where D.H. had stayed in 1924 and 1925 (see page 31).

When it was time to return East, O'Keeffe brought back, as souvenirs, the bones she had found in the New Mexican desert. Stieglitz thought it a waste of money to have had the bones shipped east. At Lake George, she painted her first skull paintings. Her great American painting is entitled *Cow's Skull-Red, White, Blue.* It was her response to the men of New York City and their "Great American Everything." Her first western paintings were successfully shown in February, 1930 at Steiglitz's new gallery, An American Place.

In 1930 O'Keeffe returned to Taos and again stayed at Mabel's. Mabel had a very domineering personality which O'Keeffe needed to get away from so the following year when she again returned to New Mexico, she rented a cottage at the H and M Ranch near Alcalde.

Then, in 1932, O'Keeffe stayed in the East and traveled to Canada. She accepted a commission for a large mural at the new Rockefeller Center's Radio City Music Hall in New York. Stieglitz was opposed to the project. That fall difficulties with the mural at Radio City Music Hall strained O'Keeffe to the limit. The building was behind schedule and she had inadequate time to do the job. She had a nervous breakdown and was hospitalized for weeks. Some researchers have written that her desire for a child which Stieglitz opposed was a contributing factor. Stieglitz did not want children for two reasons: his daughter Kitty had suffered a total post-partum schizophrenic breakdown and he also felt it would dissipate O'Keeffe's creative energy. Her recovery took a year and a half, including trips to Bermuda for recuperation.

By the summer of 1934 she was back in New Mexico and stayed at the Ghost Ranch (see page 35), near Abiquiu. She climbed, drove, and rode through the incredible red and yellow cliffs. For the next several years she spent her summers painting in New Mexico and her winters in New York City with her husband who was becoming increasingly frail.

From 1930 to 1946 yearly exhibitions of her new works were held at Stieglitz's gallery, An American Place. Her 1934 retrospective show was a great success and the Metropolitan Museum of Art purchased a work for their collection. Stieglitz managed the sale of O'Keeffe's paintings and he was notorious about finding the right home for them. Her shows were well attended and reviewed. She was somewhat of a celebrity and had even been featured in a *Life Magazine* photo essay in 1938. Her paintings, frequently abstractions of shapes from nature, were controversial and psychoanalyzed by some critics. Many viewers thought the organic natural shapes were very sexual.

Luckily, she was able to remove herself from the frenzied art scene in New York City. In 1939 she traveled to

Hawaii on a commission from the Dole Company with an assignment to paint a pineapple plant. For some reason it was always hard for her to produce on demand and although she enjoyed Hawaii she never painted the pineapple while there! Dole later sent a plant to her on the mainland and she finally painted *Pineapple Blossom.*

In 1940 she returned to New Mexico and became a property owner. She bought the house where she had been staying at Ghost Ranch, the Rancho de los Burros (see page 37). Isolation was one feature of the house and she eventually kept Chow dogs as guardians and companions. O'Keeffe valued privacy as well as friendship. Although she has been frequently portrayed as an independent loner living like a hermit, she actually had live-in household help and assistants as well as visits from family and friends. She had remained close to her sisters Claudia and Anita but resented what she considered the competing artistic efforts of her sisters Ida and Catherine. This was a very productive period for her and she often painted for ten hours a day. Searching for inspiration in the landscape she explored the entire area by foot, horseback and car but was too afraid to camp out overnight by herself.

Although she enjoyed isolation and privacy, O'Keeffe was not just a detached artist removed from society. She supported the vote for women and the Equal Rights Amendment and in 1944 wrote to Eleanor Roosevelt criticizing her for opposing the ERA. O'Keeffe considered herself an artist and did not necessarily like being called a *woman* artist. She had many influential friends, including Frank Lloyd Wright, Aaron Copland, Sherwood Anderson, and Alexander Calder. But she didn't interact much with the other artists in New Mexico, except for a few, like Cady Wells and Dorothy Brett. She could be a difficult friend and eventually broke off with many of her old friends, most notably Anita Pollitzer and her long term agent in New York, Dorothy Bry.

During the forties there were new paintings as well as retrospective exhibits of O'Keeffe's works at the Art Institute of Chicago and at the Museum of Modern Art in New York City. As museums and collectors acquired her works, her financial

security and the freedom that could buy were assured. On the last day of 1945 she purchased her second home in New Mexico. The house, located on a cliff top in Abiquiu (see page 47), was less isolated than her Ghost Ranch home. Although only about 15 miles apart, the poor roads at the time made it seem much farther, especially in the winter. There were to be many changes for O'Keeffe in the next few years: her husband, Alfred Stieglitz, died in July, 1946. She spent several years organizing his voluminous estate. Finally she had nothing left to tie her to the East. In 1949 she moved permanently into her totally renovated house in Abiquiu, New Mexico.

In 1949 she was elected to the National Institute of Arts and Letters. Now she used her time and energy to paint almost everything around her. Sometimes she did several studies of the same object, usually increasingly abstract. There are many paintings of the patio door in her Abiquiu home, and one of these is in the museum in Santa Fe (see page 51). The surrounding cliffs, red hills, Pedernal, flowers, bones, tree stumps, rivers, and roads all inspired her. She also indulged her lifelong passion for music with top of the line stereo equipment and musical evenings out in Santa Fe. O'Keeffe would have her hair done at the beauty shop in the historic La Fonda Hotel before attending performances at the Santa Fe Opera or the Santa Fe chamber music series. (see page 53).

From 1952 to 1963 her works were exhibited at the Downtown Gallery in New York City. Incredibly, it wasn't until 1953, when she was in her mid-sixties, that O'Keeffe first visited Europe. Infected with travel fever, she went to Mexico and Peru and back to Europe. Then in the winter of 1959-1960 she traveled around the world. In 1961 she took a ten day raft trip down the Colorado River. These trips provided new stimulation and she discovered she liked seeing from above. Her largest work, painted in 1965, *Sky Above Clouds IV*, is of the view from a plane. In 1970 a retrospective at the Whitney Museum in New York City was critically acclaimed and brought her renewed widespread attention.

But things changed in 1971 when she lost most of her central vision. She was frightened and depressed. Then,

O'Keeffe met a young potter, Juan Hamilton, in the summer of 1973 at Rancho de los Burros. He had come to ask her for a job. Although an American, he spoke fluent Spanish and looked remarkably like Stieglitz had as a young man. He did odd jobs and eventually became a full time helper. O'Keeffe had done some sculptures when she was younger and under Hamilton's influence she returned to that medium. The large sculpture *Abstraction* which was in her Abiquiu yard for many years is now in the Georgia O'Keeffe Museum in Santa Fe (see page 55). In her later years Juan Hamilton became the trusted friend, secretary, and assistant that she needed. Together they worked on her memoir which was published in 1976 and contains over 100 color reproductions of her works. With Hamilton she was able to attend retrospective exhibits and received several honorary degrees in person. She even went to Washington, DC. in 1977 for her ninetieth birthday. When she returned home she painted an obelisk series inspired by the Washington Monument.

In her mid-nineties, O'Keeffe moved to her final home in Santa Fe, on the historic Old Santa Fe Trail with Juan Hamilton, his wife and their two children. On March 6, 1986, at ninety-eight, Georgia O'Keeffe died at Saint Vincent's hospital in Santa Fe, New Mexico. At her request there was no memorial service. It has been written that Juan Hamilton scattered her ashes on Pedernal as she had wanted. Others claimed the dispersal site as Rancho de los Burros. Wherever her ashes are, her spirit and art have reached all corners of the planet. And today people from around the world come to New Mexico to share in the feeling of being in the "faraway nearby". Her legacy also lives on in the paintings she left behind which are on exhibit in museums around the world.

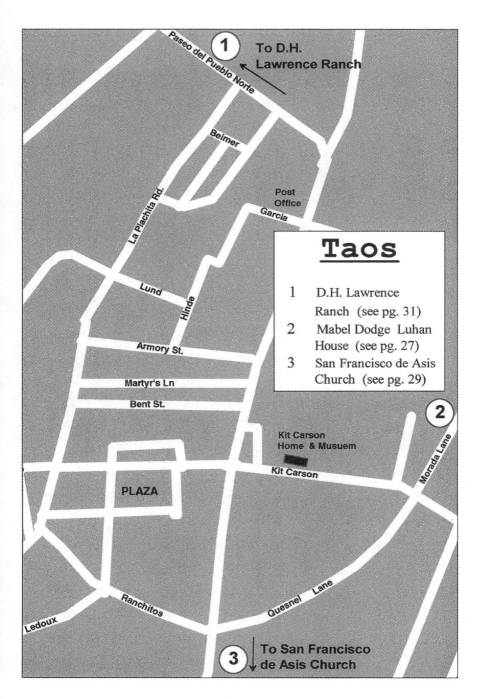

To D.H. Lawrence Ranch

Taos

1 D.H. Lawrence Ranch (see pg. 31)
2 Mabel Dodge Luhan House (see pg. 27)
3 San Francisco de Asis Church (see pg. 29)

Paseo del Pueblo Norte

Beimer

La Plachita Rd.

Post Office

Garcia

Lund

Hinde

Armory St.

Martyr's Ln

Bent St.

Kit Carson Home & Musuem

Kit Carson

PLAZA

Morada Lane

Ranchitos

Quesnel Lane

Ledoux

To San Francisco de Asis Church

ALLISON GOONEY
© '88

Mabel Dodge Luhan House

Mabel Dodge Luhan was a wealthy heiress who felt that Taos could be the center of true American art and culture. She married a Taos Pueblo Indian, Tony Luhan in 1918 and they built their Taos home in a combination Pueblo/ Spanish style. The house was designated a national historic landmark in 1991.

The Mabel Dodge Luhan House is located at the end of Morada Lane, just a few blocks northeast of the Taos Plaza. The rambling adobe building is surrounded by large trees and, in Mabel's time, was called *Los Gallos* because of the Mexican ceramic roosters on the roof.

Mabel wanted to surround herself with great artists and intellectuals. Her guests included D.H. Lawrence, Willa Cather, Georgia O'Keeffe, John Marin, Robinson Jeffers, Ansel Adams, Leopold Stokowski, Martha Graham, Laura Gilpin and Carl Jung. Books have been written by and about Mabel and there is even one, *Utopian Vistas,* which is about the house .

The property had several outbuildings and it was in one of these, previously occupied by D.H. Lawrence, that O'Keeffe stayed in the summer of 1929. What is now a large parking lot was an alfalfa field, and O'Keeffe would walk along a flower-lined path to visit Mabel in her big house. The red hollyhock and blue larkspur on that path inspired several of O'Keeffe's paintings. During the summers of 1929 and 1930 she also worked on *The Lawrence Tree* and *Ranchos Church.* Writing in *Creative Art* magazine Mabel said, "...one cannot tell more than the paintings tell. But whoso has eyes may see what Georgia felt and lived through and participated in up there."

In Taos O'Keeffe learned how to drive and often worked in the car, removing the back seat to make more room. She went camping and horseback riding with Tony Luhan, making Mabel jealous. That, plus Mabel's domineering personality motivated O'Keeffe to find her own place in New Mexico.

Today the house is an inn and conference center. A small book and gift shop is open to the public. Call (800) 846-2235 or (505) 751-9686 for more information.

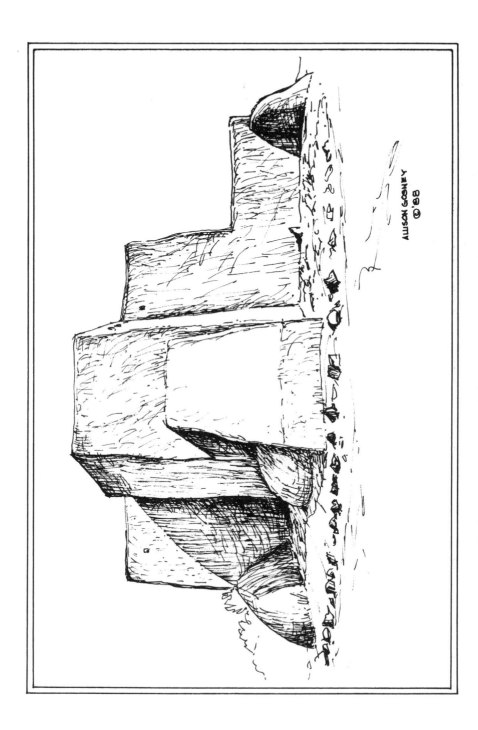

ALLISON GOONEY
©'88

Church of San Francisco de Asis

This Franciscan church, with its massive adobe walls, is one of the most painted and photographed buildings in New Mexico. As O'Keeffe noted, most artists who come to Taos have to paint it. She also painted it several times herself. Its official name is the Church of San Francisco de Asis but it's frequently referred to as the Ranchos Church.

This famous Roman Catholic church is located in the village of Ranchos de Taos, on Highway 68, four miles south of Taos. The exact time of its construction is unknown, but records show the first priest was assigned in 1815. It is now maintained in traditional mud and straw adobe by church members. The 850 parishioners and their friends, both men and women, do this masonry work on a rotating basis. For this reason the church is closed for about two weeks every year in early summer.

O'Keeffe's paintings of the church seem to capture the subtle glow of the straw in the adobe. Her paintings are from the back, where the huge buttresses create interesting shadows and shapes. She considered the church one of the "most beautiful buildings left in the United States by the early Spaniards." As was typical of her style, some of the paintings depict fragments of the building. She later expressed satisfaction with these fragments done in 1929 and 1930.

The Church is open to visitors, except on Sundays, from 9-12 and 1-4. There is a two dollar donation and a presentation about the church's history is also available. Call (505) 758-2754 for information about specific times. A beautiful book, *Spirit and Vision: Images of Ranchos de Taos Church*, can be purchased in paperback for about twenty dollars. It contains an accurate history of the church and is illustrated by many of the different artists who worked in New Mexico. Please note: there are no O'Keeffe paintings in the church.

The small plaza around the church is lined with a few galleries and gift shops as well as a small restaurant. Even when these are closed, it's worth the time to drive around the plaza to view the back of the church which has inspired so many artists.

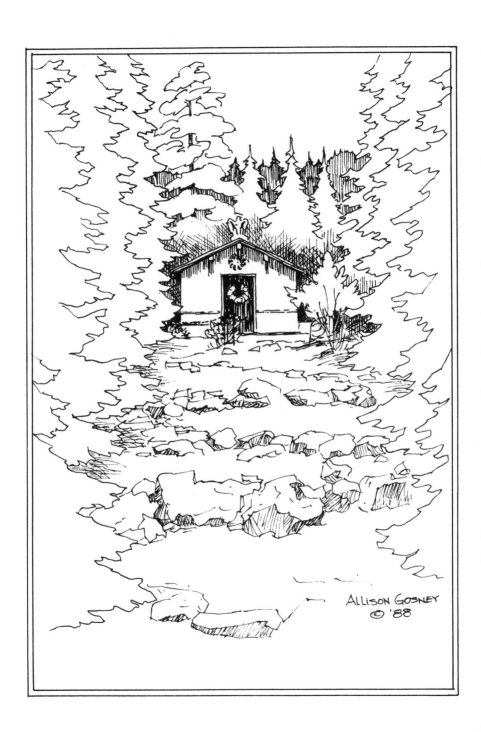

ALLISON GOSNEY
© '88

Lawrence Ranch and Shrine

O'Keeffe spent several weeks at the Lawrence Ranch during the summer of 1929. The ranch is about 20 miles north of Taos off of Route 522 near San Cristobal. Going north, a New Mexico highway historical marker on the right side marks the unpaved road to the ranch and shrine. Watch for signs with directions by the University of New Mexico, now the owners.

On summer nights in 1929 O'Keeffe would lie on the bench under the large tree in front of D.H. Lawrence's small cabin. *The Lawrence Tree* is her famous painting of that tree thrusting into a starry nighttime sky. The picture is often hung incorrectly. According to O'Keeffe the "tree should stand on its head." Today, more than seven decades later, that very pine still stands next to the cabin Lawrence once wrote in.

Kiowa Ranch, as it was called, was a gift from Mabel Dodge Luhan to Frieda Lawrence. D.H. Lawrence and his wife Frieda stayed here in 1924 and 1925. Mabel's book, *Lorenzo in Taos* chronicles those days.

When D.H. Lawrence died in Europe in 1930, Frieda returned to New Mexico with a new husband, Angelo Ravagli. O'Keeffe was a friend of Frieda's and visited her at the ranch several times. In 1936 it was "Angie" who built a tiny simple shrine, incorporating Lawrence's own ashes. The interior was designed by Lawrence's faithful friend, Lady Dorothy Brett. Brett was a character herself, who had followed Lawrence to New Mexico from England. Nearly deaf, she always carried a large ear trumpet and was considered odd. Also an artist, she settled near Taos, became a U.S. citizen, and was a friend of O'Keeffe's, who also considered her eccentric.

The shrine, which is open to the public, is approached on foot up a steep path lined by majestic pines. Here D.H. Lawrence's ashes are interred, mixed with the concrete of the structure itself. Call (505) 776-2245 for more information. The shrine is open daily during daylight. There are no facilities here, except a single picnic table. This is appropriate since the primitiveness and remoteness is what attracted Lawrence.

Legend for Abiquiu Area

① **Abiquiu Inn** (see page 45)

② **Bodes Mercantile** (see page 45)

③ **Abiquiu Post Office**

④ **O'Keeffe House** (see page 47)

⑤ **Dar al Islam Mosque** (see page 45)

⑥ **White Place** (see page 45)

⑦ **Scienic turnoffs, picnic tables, red and yellow cliffs**

⑧ **Recreation - Abiquiu Reservoir**

⑨ **Pedernal** (see page 43)

⑩ **Ghost Ranch Conference Center** (see page 35)

⑪ **Museums of Ghost Ranch** (see page 39)

⑫ **Rancho de los Burros** (see page 37)

⑬ **Ghost Ranch Living Museum** (see page 41)

⑭ **Echo Amphitheater** (see page 43)

⑮ **Christ in the Desert Monastery** (see page 43)

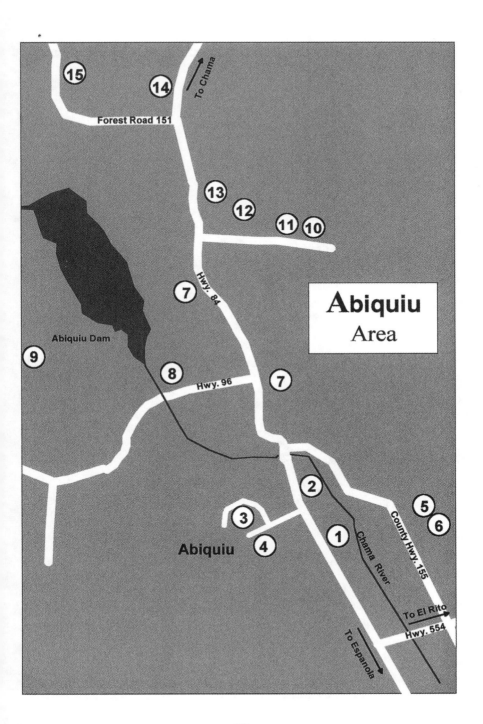

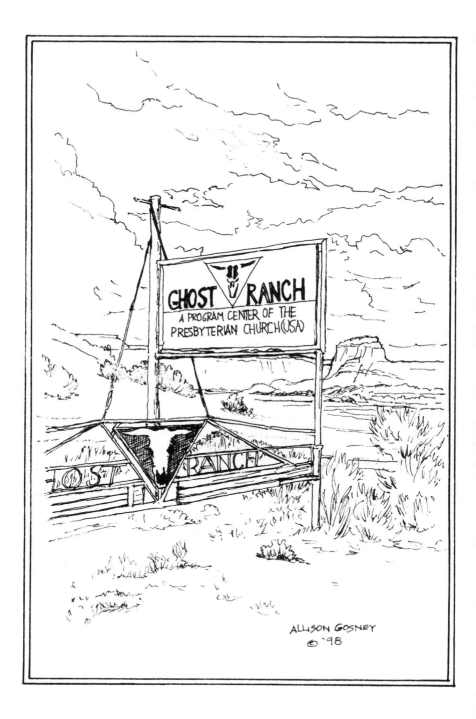

Ghost Ranch Conference Center

In 1934, when O'Keeffe first stayed at the Ghost Ranch, it was a dude ranch owned by Arthur Pack. It's about thirteen miles north of Abiquiu on U.S. Highway 84. The entrance gate is marked by a skull logo which was designed by O'Keeffe.

O'Keeffe had been staying at the H&M Ranch near Alcade. She had heard about the red cliffs and the Ghost Ranch, but couldn't find the place until she saw a ranch truck and followed it. Soon she was spending her summers in an isolated adobe called the Rancho de los Burros (see page 37). She was dismayed when she arrived without reservations in 1937 and "her" house was occupied. By 1940 she had convinced Arthur Pack to sell the house and the surrounding seven acres to her!

Today the Ghost Ranch Conference Center is a National Adult Study Center of the Presbyterian Church (USA). The ranch was donated to the church by the Pack family in 1955. The ranch's celebrity guests have included Leopold Stokowski, Andre Kastelanetz and John Wayne. Interesting details can be found in Arthur Pack's book, *We Called it Ghost Ranch*.

Seminars, art workshops, elderhostels and a variety of other programs are open to the public. It is possible to stay here on a nightly basis if space is available and arrangements made in advance. The room and board is somewhat spartan and most rooms share a bath but the scenery is magnificent. It's so spectacular that the Ghost Ranch became a Registered Natural Landmark in 1976. A plaque near the headquarters building states that the "site possesses exceptional value as an illustration of the nation's natural heritage and contributes to a better understanding of man's environment." There are two museums (see page 39) and for the adventuresome, several hikes. Please stop at the office to register before you start hiking.

There is a library and trading post where O'Keeffe books and post cards are available as well as a print of her *Red and Yellow Cliffs* painting. For information write: Ghost Ranch, Abiquiu, NM 87510 or call (505) 685-4333. Also, The Ghost Ranch Living Museum (see page 41) is only two miles away.

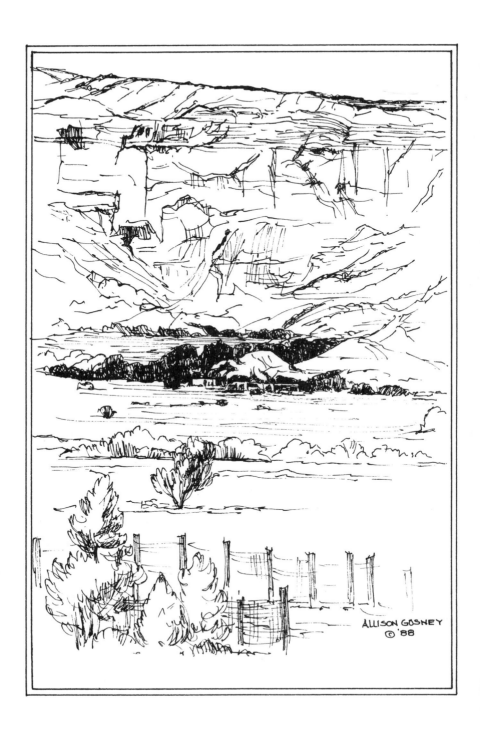

ALLISON GOSNEY
© '88

Rancho de los Burros

O'Keeffe was a loner who enjoyed privacy and solitude and sometimes found people difficult to be with. When Ghost Ranch owner Arthur Pack brought her to the abandoned, somewhat isolated house that he had built, the Rancho de los Burros, she loved it and moved right in. She was disappointed in 1937 when the house was rented to someone else. By 1940 she had convinced Arthur Pack to sell it to her!

The single-story adobe house is barely visible from the Ghost Ranch Living Museum (see page 41). Nestled at the base of the famous red and yellow cliffs, its roof is crowned by adobe chimneys. The house is U-shaped and its rooms are built around a patio that faces "her" mountain, Pedernal (see page 43). A ladder leads to the roof, where O'Keeffe spent many hours, even sleeping out all night under the incredibly starry sky. Her painting of a ladder floating to the moon was inspired by these rooftop nights. Other paintings such as *My Front Yard* and *The House Where I Live* also reflect O'Keeffe's love of the space surrounding her home. She painted the surrounding hills, cliffs, sky, trees, mountains and even the bones of dead animals.

When O'Keeffe bought the house in October, 1940, it was extremely isolated without telephone or radio, about 13 miles to Abiquiu on very poor roads. She did some remodeling, knocking out walls and adding windows to capture the view and create a large studio. There were many rattlesnakes and some had to be killed but she also realized it was she who was invading their domain. A garden was too difficult in such an arid location but in the patio natural vegetation thrived. Eventually the isolation and lack of water for gardening led her to purchase her other home in Abiquiu (see page 47). She spent winters in Abiquiu and summers at Ghost Ranch. In her later years she could no longer make the trip to the ranch and she missed it deeply, often asking visitors to take her there.

The Rancho de los Burros is not open to the public. Juan Hamilton inherited the property from O'Keeffe. He sold it to the Marion family, who developed the Georgia O'Keeffe Museum in Santa Fe (see page 55), for use as a study center.

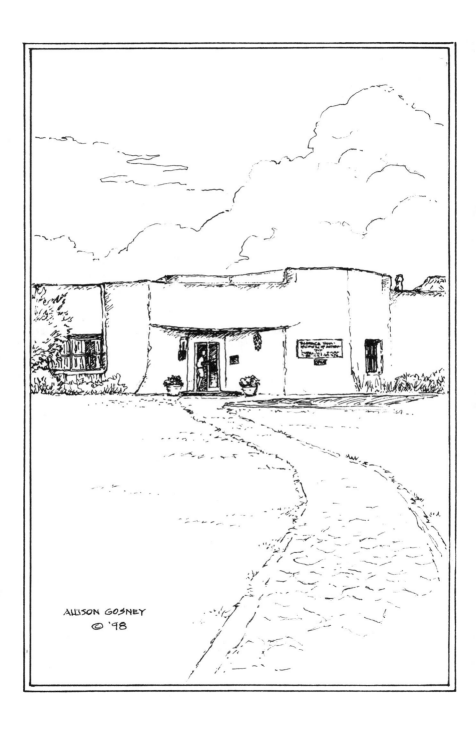

ALLISON GOSNEY
© '98

Museums of Ghost Ranch

The Florence Hawley Ellis Museum of Anthropology and the Ruth Hall Museum of Paleontology are located in the same building at the Ghost Ranch Conference Center (see page 35). Both museums are open to the public and dedicated to the study of the land and peoples of northern New Mexico.

The exhibits in the Florence Hawley Ellis Museum are artifacts from the local Chama Valley and Gallina cultural sites as well as works by contemporary Native American and Hispanic artists, spanning the 12,000 years of human habitation in the area. Dr. Ellis taught at the University of New Mexico and at the Ghost Ranch. A popular hands-on Archaeology Seminar which she used to teach is offered during the summer.

The Ruth Hall Museum of Paleontology is a natural laboratory for the study of ancient rocks and bones as well as modern plants and animals. Since the 1850s, scientific expeditions have explored the Ghost Ranch area. Triassic reptiles from 200 million years ago, the first dinosaurs and armored reptiles, whose bones have been found here are on display. The museum is dedicated to the spirit of exploration and learning of Ruth Hall, the wife of the ranch's first director. Her interest in old bones led her to become an amateur paleontologist.

Old bones in a museum can seem scientific but after seeing O'Keeffe's bones on canvas, the sculptural and abstract qualities are more obvious. Perhaps not apparent to everyone, however. Even Stieglitz rebuked O'Keeffe for wasting money when she sent a barrel of bones back to New York. In fact O'Keeffe's most treasured possessions were bones, shells and stones. She had a rattlesnake skeleton under glass and even stole a favorite black rock from her friend, photographer Eliot Porter. She hiked and camped all over this area seeking scenes to paint as well as rocks and bones.

For those with time and energy there are several hikes in the area; please register at the office. It's only about 2 miles to the Ghost Ranch Living Museum (see page 41). For information contact the Ghost Ranch Conference Center (see page 35).

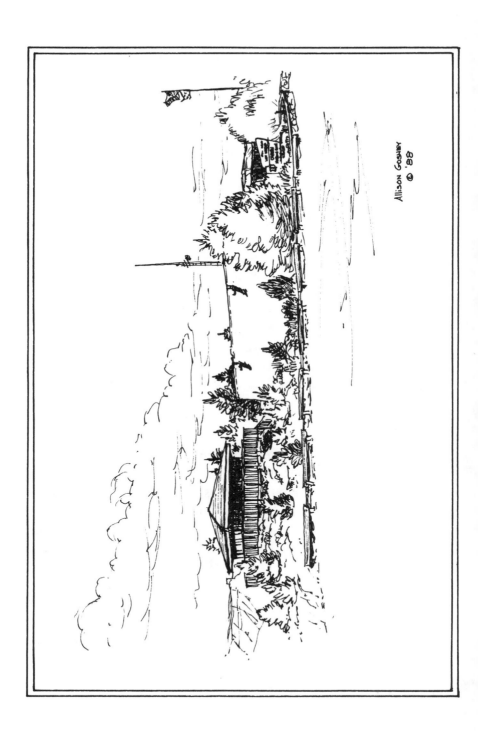

Allison Goshey
© '88

Ghost Ranch Living Museum

This is the place! Located on U.S. Highway 84, about 14 miles north of Abiquiu, the Ghost Ranch Living Museum offers today's visitor the same spectacular vistas that so enchanted Georgia O'Keeffe. The museum is on part of the old Spanish *Piedra Lumbre* land grant, a name which means rocks afire in English. Indeed the amazing red, yellow and orange cliffs were frequently painted by O'Keeffe. Sitting here, in the Ranger Overlook tower feels like being in the middle of her painting, *Red Hills with Pedernal* (1936). That painting is often on display at the Museum of Fine Arts in Santa Fe (see page 51).

Also from the museum's Ranger Overlook tower, the Rancho de los Burros (see page 37) is barely visible. It's nestled at the base of the red and yellow cliffs, at the foot of some small red hills. O'Keeffe climbed most of the cliffs in this area and she also enjoyed horseback riding and camping, but was afraid to sleep out by herself. For another truly O'Keeffean experience, the Echo Amphitheater Recreation Area is three miles north and offers hiking and camping. O'Keeffe loved this country and her ashes are scattered in this landscape, under the red and yellow cliffs, in sight of Pedernal. Here is her final resting place.

The Ghost Ranch Living Museum opened to the public in 1959 and features the wildlife and habitats of New Mexico. It is operated by the U.S. Forest Service as a part of the Carson National Forest. It's purpose is to instill in visitors a sense of stewardship towards the ecosystems of northern New Mexico. The prairie dog, beaver, bobcat, bear, badger, deer, rattlesnake and other animals, as well as the geological features of the area, are exhibited and explained. The museum even has a small auditorium where people can view a video about O'Keeffe and the gift shop has a good selection of O'Keeffe related items.

The museum is open every day from 8 to 4, except Mondays and holidays. Entry is by suggested donations of three dollars per adult, two for students, children free. Picnic tables, restrooms, vending machines and a drinking fountain are available. For more information call (505) 685-4312.

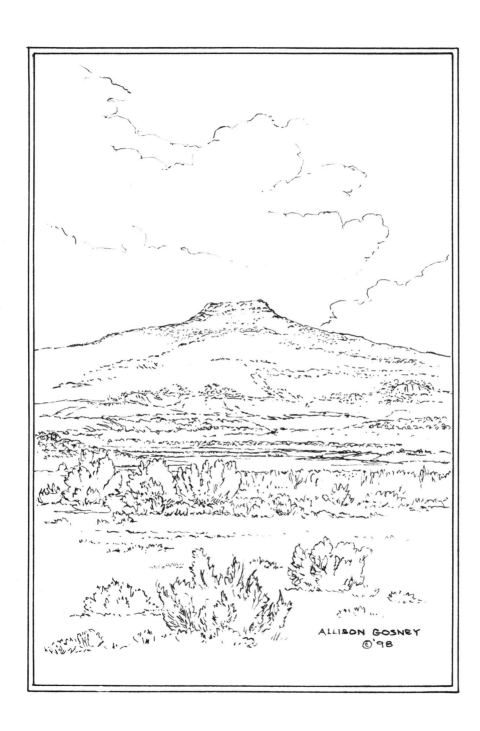

Pedernal

O'Keeffe was in love with the 9,862 foot tall Cerro Pedernal Mountain which she could see from her Ghost Ranch home. She called it "her mountain" and its beautiful, mysterious silhouette can be seen in several of her paintings.

There are convenient places to stop and enjoy the presence of the mountain. There is a small rest area with picnic tables in a scenic turn-off from Highway 84 with a wonderful view of Pedernal, the Chama River Valley and Abiquiu Reservoir. At the Reservoir there are campsites, picnic tables and recreational facilities such as boating or horseback riding.

Although O'Keeffe was not conventionally religious, she was a frequent visitor at the Christ in the Desert Monastery. Founded in 1964, it is located in the desolate area to the northwest, past the Ghost Ranch. A somewhat arduous thirteen mile trip on unpaved Forest Service Road 151 leads to the complex run by the Benedictine Monks. In her book, C.S. Merrill writes about accompanying O'Keeffe, (in O'Keeffe's Volkswagon van) to a sunrise Easter service. They sat in the dark, incense-filled church listening to the ceremony in Latin and Spanish. It is interesting to note that although O'Keeffe lived and worked amid Spanish speaking people for many years, she never learned to speak the language.

The vistas from the monastery area are splendid and visitors are welcome. The adobe chapel, with its huge windows was designed by George Nakishima. Items such as incense and recordings of Gregorian chants are available from the gift shop which is open daily and also accessible on-line. Sunday Mass is celebrated at 9:15 a.m. It is possible to attend a retreat, write to: Guestmaster at the Monastery, Box 270, Abiquiu NM 87510.

Going north on Highway 84 about one mile after the turn for the monastery, there is a sign indicating the entrance to the Echo Amphitheater. C.S. Merrill recounts that O'Keeffe could "see" a giant Modigliani in the sandstone rocks there. The area which has picnic and camping facilities is part of the Carson National Forest run by the U.S. Forest Service.

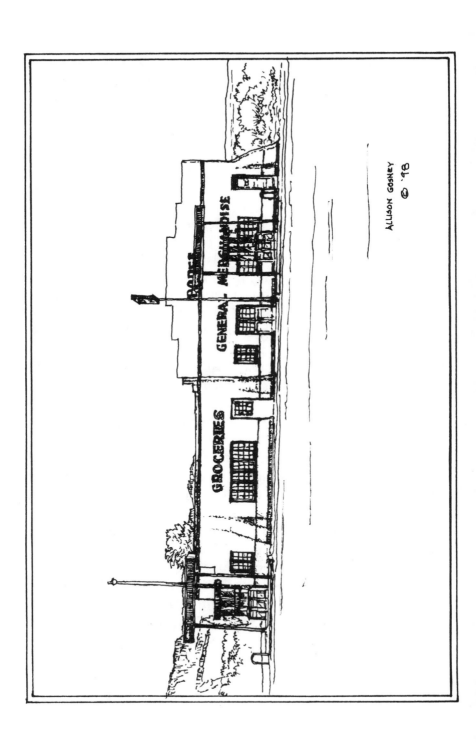

ALLISON GOSNEY © '98

Bode's Mercantile

There has been a Bode's Mercantile in Abiquiu since 1919. People for miles around rely on this real general store for necessities and the variety of merchandise is astounding. Stop at Bode's on Highway 84 to fill up the car, eat at the sit-down deli and bakery, buy O'Keeffe souvenirs, books, maps and items for fishing (including licenses), hiking and camping. There are some great picnic spots from which to enjoy the fantastic red and yellow cliffs just north of Abiquiu on Highway 84. Bode's is open seven days a week, call (505) 685-4422.

O'Keeffe had a charge account at Bode's since it was the store nearest her Ghost Ranch home in addition to being just across Highway 84 and down the hill from her Abiquiu home (see page 47). Across from Bode's is a gallery, gift shop and the tiny Abiquiu Post Office, a good place to mail O'Keeffe cards. The road continues past the walled O'Keeffe house and then on to the village of Abiquiu. Please respect the privacy of the inhabitants and note that photos are not permitted in the village.

Please be especially cautious of the roads and traffic. Once when O'Keeffe walked to Bode's a stray dog that hung out by her back door followed her and was killed by a semi truck. Since she loved dogs, she even arranged for its burial.

The comfortable adobe style Abiquiu Inn is located on Highway 84, just south of the town. The inn has several rooms, an excellent restaurant, small gallery and a gift shop carrying O'Keeffe items. Call (505) 685-4378 for more information.

O'Keeffe loved this area and painted almost everything: the cottonwood trees, the Chama river, even the road. A favorite painting location was an outcropping of gray volcanic rock, called the *Plaza Blanca* or White Place, now owned by the Dar al Islam Mosque. To find it drive north from Bode's for .7 of a mile and turn right at County Road 155 and after 2.3 miles take Mosque Road for .7 of a mile. For the White Place take the right hand fork in the road and look for a wooden sign at the parking area. Wear sturdy shoes to hike around. The adobe mosque is worth a visit too. For information call (505) 685-4515.

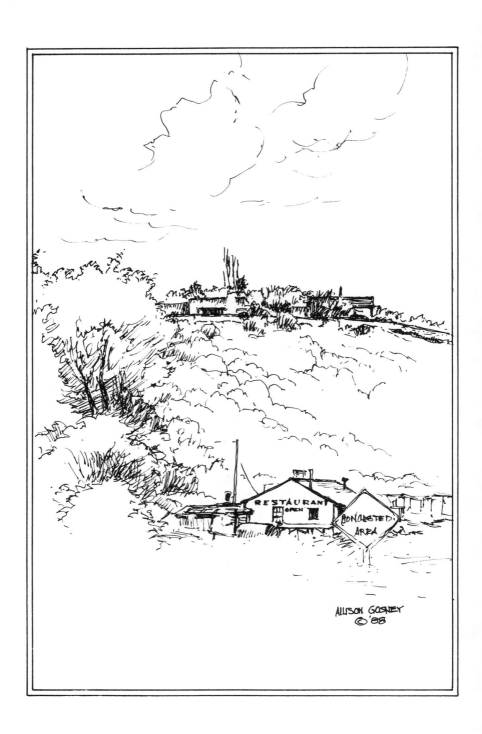

Abiquiu House

O'Keeffe's Ghost Ranch home was her favorite, but its isolation and insufficient water for gardening led her to nearby Abiquiu. She found an abandoned adobe house on a mesa with commanding views and water rights. She finally bought it from the Catholic Church in 1945. Driving from Espanola on Highway 84, the house is barely visible atop the cliffs on the left shortly after milemarker 282.

Extensive renovations were undertaken with O'Keeffe's friend, Maria Chabot in charge. O'Keeffe liked the soft sculptural qualities of adobe. Different soils were incorporated into the mud to add color. She was fascinated by the old wood door in the inner patio and eventually painted an entire *Patio Series*. Glazed glass skylights provided ventilation and light and plate glass windows were installed to capture the views. In her book O'Keeffe wrote, "from one window I see the road toward Espanola, Santa Fe and the world. The road fascinates me...." She did numerous paintings of that view, including *The Winter Road* and *Road Past the View I*. The view from that very road, Highway 84, is a good place to catch a glimpse of the house. Looking up, the large windows of her bedroom and some chimneys are visible, jutting out above an adobe wall.

A wall surrounds the property and parking lot, an area where O'Keeffe often walked to get exercise in her later years. Trees, vegetables, fruits, herbs and flowers were planted in the large garden. O'Keeffe also needed space for an art studio and her treasures: books, records, bones, rocks and even a rattlesnake skelton under glass. Her decor was modern with pieces by Saarinen and Eames, a Barwa lounger and Calder mobile. She also had built-in adobe bancos, a simple plywood table, sophisticated stereo system and liked bare lightbulbs.

The Georgia O'Keeffe Foundation owns the house which is open on a limited basis. Hour-long tours are held from April through November, on Tuesdays, Thursdays and Fridays only. Tours start from the Abiquiu Inn and cost twenty dollars per person. Call (505) 685-4539 well in advance to make reservations which are absolutely necessary.

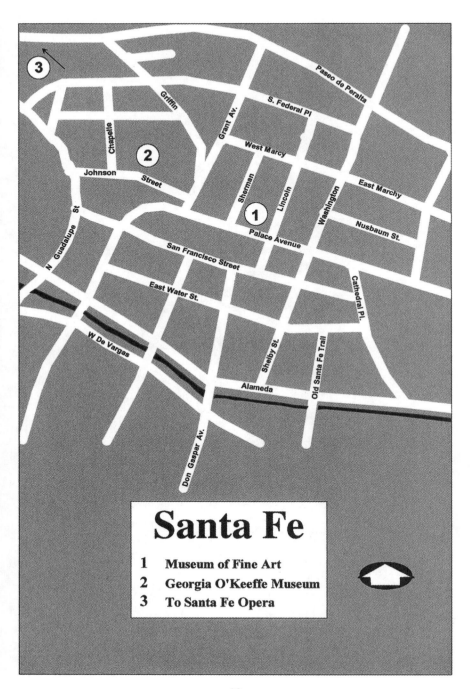

Santa Fe

1 Museum of Fine Art
2 Georgia O'Keeffe Museum
3 To Santa Fe Opera

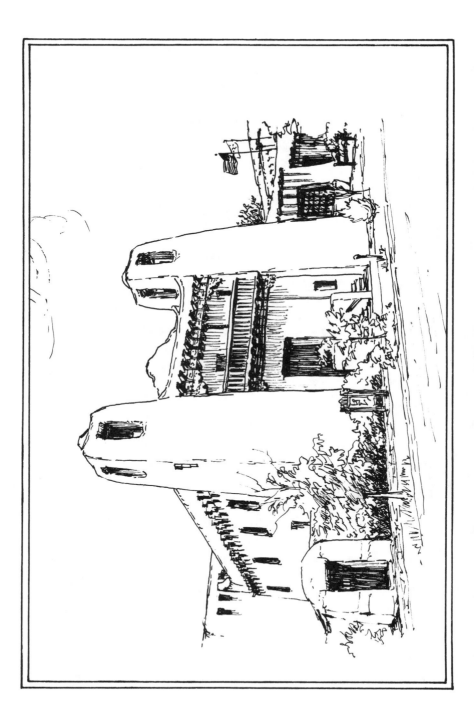

Santa Fe Museum

The Museum of Fine Arts, a part of the Museum of New Mexico, is located at 107 East Palace Avenue in Santa Fe. Its collection features works by American artists who have been inspired by New Mexico from the early Taos masters to today's avant-garde.

The museum owns several O'Keeffe's including *Grey Hill Forms, From the River - Light Blue, In the Patio II* and *Red Hills and Pedernal* which are especially evocative of New Mexico and the Abiquiu area. The museum has a wide range of constantly changing exhibits but there are usually some O'Keeffe paintings on display.

The building was built in 1917 in the pueblo-revival style and is just a few steps from the historic Santa Fe plaza. In addition to its art galleries the building also houses the Saint Francis auditorium where the Santa Fe Chamber Music Festival holds its performances in July and August. O'Keeffe loved music (see page 53) and attended many concerts in the lovely auditorium.

Also, look on the sidewalk around the museum where there are several plaques installed by the city commemorating some of the outstanding people who are affiliated with New Mexico, including Georgia O'Keeffe.

The museum is open every day except Mondays from 10 to 5 and the general admission fee is five dollars. The museum is open on Friday evenings from 5 to 8, free of charge. The gift shop also sells O'Keeffe related items. A good deal for art and history lovers is the ten dollar four consecutive day pass which includes unlimited entry to the Museum of International Folk Art, Museum of Indian Arts and Culture, Palace of the Governors and the Georgia O'Keeffe Museum (see page 55). For additional information, call (505) 827-4468.

Music

O'Keeffe loved music nearly as much as painting. She learned to play the piano and violin as a child and enjoyed music for most of her life. Both of her New Mexico homes had top-level stereo equipment. Her collection of albums included works by Bach, Beethoven, Hayden, Mendelssohn, Mozart, Schubert, Schumann and Vivaldi. She had five different recordings of Beethoven's piano sonata, *Appassionata*. She was not afraid to express her musical opinions; in a 1968 thank you note to Aaron Copland she wrote "It has always annoyed me that your music does not speak to me...." In some of her paintings, such as her 1919 work, *Music - Pink and Blue II,* O'Keeffe actually tries to express the feeling of music. The music O'Keeffe enjoyed in New Mexico continues to this day.

The Santa Fe Chamber Music Festival had a special twenty year relationship with O'Keeffe. From the Festival's founding in 1972 until 1992, the works of O'Keeffe were featured on a series of festival posters. During her last years in Santa Fe, when she could no longer attend concerts, a string quartet from the orchestra came to play for her! The annual Chamber Music Festival is held every summer from mid-July to mid-August, with most events in the Saint Francis Auditorium of the Santa Fe Museum of Fine Art (see page 51). The Festival also sponsors a lecture series, concert previews and free open rehearsals. For additional information call (505) 983-2075.

Less well known is the fact that O'Keeffe was an opera fan. She attended The Santa Fe Opera many times and was a friend of Santa Fe Opera founder and General Director John Crosby. Call (505) 986-5900 for schedules and information.

O'Keeffe would also travel for hundreds of miles to attend the special feast day dance ceremonies at the various Indian pueblos. Dances that can be seen include: the Deer Dance at San Juan in February, the Corn Dances at San Ildefonso in August and September and even a Vespers and Matachinas Dance at various pueblos on Christmas Day. For times call the Indian Pueblo Cultural Center at (800) 766-4405.

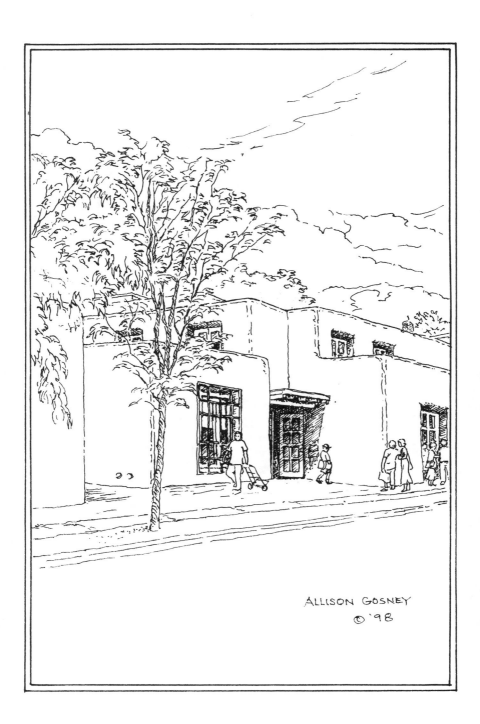

ALLISON GOSNEY
©'98

Georgia O'Keeffe Museum

In July of 1997, The Georgia O'Keeffe Museum opened in Santa Fe, New Mexico. The private museum was founded by Anne and John Marion and The Burnett Foundation and has a collegial association with the Museum of New Mexico. It is one of the few museums in the world devoted to one artist.

The O'Keeffe Museum has more than 100 paintings, watercolors, drawings and sculpture in its collection, making it the world's largest repository of her work. The goal of the museum is to have as many people as possible better understand her work and why it is so popular. The museum has been a big success and much busier than anticipated.

It is unusual for an artist to be both respected by academics and achieve popular acclaim as O'Keeffe has. From the first her art instructors recognized her abilities. As early as 1902 she was awarded a gold pin for art at the Sacred Heart School. At Chatham she was recognized as "queen of the art studio" and was art editor of the yearbook. In 1908, at the Art Students League in New York, she won the Chase Still Life Scholarship. When Alfred Stieglitz saw her work in 1916 he immediately arranged a showing. Later there were numerous exhibits and many honorary degrees. Also, a medal from the American Academy of Arts and Letters in 1962, a gold medal from the National Institute of Arts and Letters in 1970 and the National Medal of Arts in 1985. Nearly a century of acclaim is testimony to her superior technical skills especially in her use of color, line and proportion. Her own museum is well deserved.

Architect Richard Gluckman designed the 13,000 square foot adobe building which has ten galleries with skylights and a patio for O'Keeffe's sculpture, *Abstraction*. The museum is located at 217 Johnson Street in downtown Santa Fe and is open from 10 to 5, Tuesdays thru Sundays, and from 5 to 8 on Friday evenings when entry is free. The general admission fee is five dollars. There is an excellent bookstore/giftshop and the Cafe features the healthy vegetarian type cuisine that O'Keeffe preferred. For more information especially about O'Keeffe related lectures and special events call (505) 995-0785.

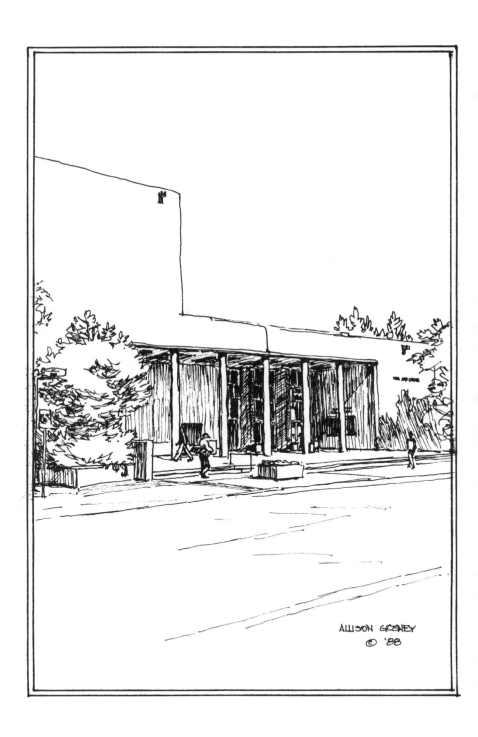

ALLISON GOSNEY
© '88

Albuquerque Museums

Two museums in Albuquerque, The University Art Museum and The Albuquerque Museum, contain excellent examples of O'Keeffe's paintings.

The University Art Museum, part of the College of Fine Arts, is located in the Fine Arts Center on the University of New Mexico campus, off Central Avenue. The attractive campus is a showplace of various styles of adobe architecture. The Fine Arts Center, with its front wall of high windows, is also constructed in adobe style.

Inside, on the lower level, there are generally three of O'Keeffe's works hanging: *White Flower, Dead Cedar Stump*, and *Gray Hill Forms. Gray Hill Forms* shows the area she loved to camp in and paint, which she named "The Black Place," about 150 miles from Ghost Ranch. She wrote, "it looks like a mile of elephants - gray hills all about the same size with almost white sand at their feet." A fourth O'Keeffe, *Tent Door at Night*, a watercolor done in 1913, is too delicate for permanent hanging. The museum is free and open every day except Monday (closed in late May). Call 277-4001 for times and information.

The Albuquerque Museum is located at 2000 Mountain Road, N.W., in the historic Old Town section (across the street from the Museum of Natural History). One O'Keeffe is usually on display, the stunning *Gray Cross with Blue*. Painted in 1929, it is almost certainly of a Calvario cross that used to be on the road near Alcalde. Calvario crosses were used in secret Penitente rituals, and O'Keeffe painted many of them. The museum is open daily, except Mondays and holidays, from 9 to 5. Both admission and parking are free. Call 242-4600 for information about exhibits and events.

Both museums have gift shops which sell books, cards and posters featuring O'Keeffe's works.

There is also a school in Albuquerque named after O'Keeffe, additional evidence of the esteem and respect the people of New Mexico have for her.

Bibliography

Adato, Perry Miller, *O'Keeffe*, videotape, WNET/Thirteen, 1977.

Barkan, Rhode and Sinclaire, Peter, *From Santa Fe To O'Keeffe Country: A One Day Journey Through the Soul Of New Mexico*, Adventure Roads Travel/Ocean Tree Books, Santa Fe, 1996.

Berry, Michael, *Georgia O'Keeffe*, Chelsea House Publishers, New York, 1988.

Castro, Jan Garden, *The Art & Life of Georgia O'Keeffe*, Crown Publishers, Inc., New York, 1985.

Cowart, Jack and Juan Hamilton, *Georgia O'Keeffe: Art and Letters*, Little, Brown and Company, Boston, 1987.

Eisler, Benita, *O'Keeffe and Stieglitz: An American romance*, Doubleday, New York, 1991.

Gherman, Beverly, *Georgia O'Keeffe the "Wideness and Wonder" of Her World*, Atheneum, New York, 1986.

Hogrege, Jeffrey, *O'Keeffe: The Life of an American Legend*, Bantam Books, New York, 1992.

Israel, Franklin, *"Architectural Digest Visits: Georgia O'Keeffe,"* Architectural Digest, July, 1981, p. 77.

Lisle, Laurie, *Portrait of an Artist: A Biography of Georgia O'Keeffe,"* Washington Square Press, New York, 1986.

Loengard, John, *Georgia O'Keeffe at Ghost Ranch: A Photo-Essay*, Wtewart, Tabori and Chang, New York, 1995.

Looney, Ralph, *O'Keeffe and Me: A Treasured Friendship*, University Press of Colorado, Niwot, 1995.

Luhan, Mabel Dodge, *"Georgia O'Keeffe in Taos,"* Creative Arts, June, 1931, p. 407.

Merrill, Christopher, and Bradbury, Ellen, Editors, *From the Faraway Nearby, Georgia O'Keeffe as Icon*, Addison-Wesley Publishing Company, Reading, 1992.

Merrill, C.S., *O'Keeffe: Days in a Life*, La Alameda Press, New Mexico, 1995.

O'Keeffe, Georgia, *Georgia O'Keeffe*, Viking Press, New York, 1977.

Pack, Arthur Newton, *We Called It Ghost Ranch*, Ghost Ranch Conference Center, New Mexico, 1979.

Patten, Christine Taylor with photographs by Myron Wood, *O'Keeffe At Abiquiu*, Harry N. Abrams, Inc., Publishers, 1995.

Patten, Christine Taylor and Alvaro Cardona-Hine, *Miss O'Keeffe*, University of New Mexico Press, Albuquerque, 1992.

Pollitzer, Anita, *A Woman On Paper: Georgia O'Keeffe*, Simon & Schuster, Inc., New York, 1988.

Robinson, Roxana, *Georgia O'Keeffe: A Life*, Harper & Row, Publishers, New York, 1989.

Rudnick, Lois Palken, *Utopian Vistas: The Mabel Dodge Luhan House and the American Counterculture*, University of New Mexico Press, Albuquerque, 1996.

Stieglitz, Alfred, *Georgia O'Keeffe: A Portrait*, Metropolitan Museum of Art, New York, 1988.